FREEDOM
FROM
BONDAGE

FREEDOM FROM BONDAGE

The Poetic Messagez of A Warrior

Ryan "Liberation" Baldwin

authorHOUSE®

AuthorHouse™
1663 Liberty Drive
Bloomington, IN 47403
www.authorhouse.com
Phone: 1-800-839-8640

© 2012 by Ryan "Liberation" Baldwin. All rights reserved.

No part of this book may be reproduced, stored in a retrieval system, or transmitted by any means without the written permission of the author.

Published by AuthorHouse 10/10/2012

ISBN: 978-1-4772-6852-0 (sc)

Any people depicted in stock imagery provided by Thinkstock are models, and such images are being used for illustrative purposes only.
Certain stock imagery © Thinkstock.

This book is printed on acid-free paper. t
Because of the dynamic nature of the Internet, any web addresses or links contained in this book may have changed since publication and may no longer be valid. The views expressed in this work are solely those of the author and do not necessarily reflect the views of the publisher, and the publisher hereby disclaims any responsibility for them.

CONTENTS

The Word ... vii
Acknowledgements .. ix
Dedication ... xiii
Credits ... xv

1. Unheard Cries ... 1
2. Emerge ("It's Time!") ... 2
3. Spiritual Minefield .. 3
4. Persecution ... 4
5. Incarceration .. 6
6. Freedom From Bondage .. 8
7. Single Sista ... 9
8. Da' Well Within ... 11
9. Liberation .. 13
10. Echoes Of The Female Moses 15
11. Take It In Stride ... 16
12. Soul Survivor .. 18
13. Shelter Us Lord .. 19
14. The Future .. 22
15. Chosen Seeds .. 23
16. No White Flags .. 24
17. Foreign Fabric .. 25
18. Servant's Heart .. 28
19. Kingdom Formin' ... 30
20. Paradise Still Livin' .. 32
21. Blessings .. 35
22. Paradise ... 37

23. Set Me Apart	38
24. Fight W/ Life	41
25. Unforgotten	42
26. Milestone	43
27. Ms. Naturalness	44
28. Promised Days	46
29. Signs & Wonders	48
30. Hedge Of Protection	50
About The Author	51
About The Book	53

In the beginning was the Word, and the Word was with GOD, and the Word was GOD.

The same was in the beginning with GOD.

All things were made by him; and without him was not any thing made that was made.

In him was life; and the life was the light of men.

And the light shineth in darkness; and the darkness comprehended it not.

John 1:1-5

ACKNOWLEDGEMENTS

First & foremost, I would like to take this time out to extend my love, honor & gratitude unto YOU (FATHER GOD) for sending My Lord & Savior Jesus Christ into the world to be a shining reflection unto all of YOUR (GOD) WILL for Us made visible, for us to appreciate, flowing from within the physical form of a Man. FATHER GOD, I thank YOU for strengthening & molding me more & more into YOUR image (Spiritual) & after YOUR likeness (w/ the free ability to make rational decisions) along my journey. I also thank YOU for blessing me with the opportunity to share with other's, the lesson's that YOU (FATHER GOD) have taught Me throughout the course of my life, that have molded me into a much better creation of YOURS. Words aren't enough to express my appreciation for the gift of using words to create poetic messages YOU (GOD) have blessed me with.

Mom,

I could never say enough to paint a picture of the appreciation that I have for You for allowing me to come into this world. If it hadn't of been for the Spirit of a Survivor that You've demonstrated since my arrival into the Universe, there's no telling where I'd be. You're the reason the fight within me is so strong & persistent. The fight to create a normal life for myself & family will continue. My Love is eternal.

Fam,

I truly appreciate the unconditional love, encouragement, support, understanding, guidance, realness, prayers, leads, insight, loyalty, knowledge, wisdom & understanding pertaining to life that has been shared to the fullest extent. I represent GOD & Us in all I do. I Love Ya'll with the Love of THE MOST HIGH. We are truly inseperable. Strong genes is a beautiful thang! I thank GOD for each of You, sun up & moon glow. I treasure Ya'll most close in heart.

Freedom From Bondage

Empress,

I thank THE MOST HIGH for allowing Our paths to cross again. Your Gifts compliment mine, in more ways than just a few. It has been a privilege growing & building with you. I appreciate the inspiration & intuition. It causes U to stick out like a sore thumb. May the world be touched by the Testimonials and Messages of Encouragement. THE MOST HIGH has placed within the soils of Our souls. Thanks-a-Million times Empress. Royal Skrollz or nothin' ya' dig!

I'm truly appreciative of everyone else that I've been blessed with the opportunity to meet, befriend & share life with throughout the duration of my days here on earth. The names are countless. Please believe me, I've came into contact with some of the most awesome individuals & I thank GOD for You all. Especially, those of You who have supported me through the trials & tribulations that I've faced.
You'll never be forgotten. You & Your Loved Ones are
always in my prayers. I'm grateful, as well, for those
of You THE MOST HIGH has placed within my path for the purpose of Me being used as a vessel to share or to receive a word of encouragement, with or from. You have each made life a lot more worth me living. I thank GOD for Ya'll!

I'm thankful for all You Gifted Brothas' & Sistas' who have been blessed with the ability to touch the masses through the extension of words capable of transforming lives. You have played an important role in me transitioning into a kingdom of positivity, out of a negative realm. All praises be unto THE MOST HIGH for You, my fellow Poets, Authors',
Freelance Writer's, Urban Magazine Journalists,
Journalists, Lyricists, Ghost-writer's &
and those who have & continue to make an uplifting impact on humanity through the creative usage of words. EVERYTHING that has ever been, was spoken into existence, by way of THE SPIRIT of THE ALMIGHTY,
thru Divine Utterance. May HE continue to utilize us to deliver
the messages HE wills for us to inspire HIS people with.

Freedom From Bondage

Lastly, I want to send a shout-out to the struggles I've endured, for coming to teach me that struggle truly does breed strength. I sincerely hope that all GOD has allowed me to put together is able to reach forward & grab someone's attention, or even lead one of HIS lost sheep back into HIS glorious light. Poetry is a passion of mine that I came to discover about a decade ago. I adore reading, as much as, reciting it. Time is irretrievably priceless. That being said, I truly appreciate each & every one of You for extending yourselves & investing Your precious time into sampling a lil' of the message that GOD has placed within my heart to share. THANKS-A-TRILLION TIMES! In all honesty, words fall short of express my gratitude.

DEDICATION

I dedicate this compilation of Spoken Word works to My Loving Mother, who has demonstrated what it means to be a soul survivor and been there for me through it all. My Father who has departed out the flesh and joined THE MOST HIGH in Spirit, the Elder's of my Family, Fam and those who have came before me for all the principle's, moral's and value's that You all have instilled within me. I treasure each and every one of Ya'll most close to heart! Know that! Your open show of Love for GOD and HIS creations, to compliment the strength, determination, unity, selflessness, respect for self and others, guidance, faith, worthiness, knowledge, wisdom and understanding, boldness, humility, service unto others, words of encouragement, uniqueness, supportiveness, inspiration, prayers and all the shining examples You individually have and continue to set shed light within this world. You are appreciated beyond words. I thank each and every one of you for the vital role you play within my world. Priceless are all the jewels you've handed down to my generation and for the generations to come. This collection of lesson's learned, thoughts, visions, ideas, battle-cries, etc... I dedicate to You, for being the radiant light within this world that You certainly are. Words aren't heavy enough to express my gratitude. Thanks-a-million times.

To My Siblings, I'm grateful to have reflections of GOD's LOVE made visible flowing out of You. Your prayer's fuel me and actions demonstrate what it means to walk in steps ordered by THE LORD. I'm proud of You for remaining on the straight and narrow path and for remaining faithful in GOD. May HE increase Your territory more and more over time. I'm appreciative of the patience you've had w/ my short-comings. May The Prince of Peace (Jesus) continue to be the light before Your path & lamp before Your feet. May Ur gifts shine through with style.

I have far too many people within my life to name while I'm expressing my dedication's. Therefore, I extend my love to all, at the same time! Last, but definitely not least, I dedicate this workmanship to my people who are surviving through the storms and being strengthened through the struggles. I do this for You. You are me. I am You. United We can! To all My Warriors behind bars, I'm Livin' proof that You definitely Can, once You are breathin' freely, if You just believe and try. THE MOST HIGH promised Restoration to HIS Chosen Seeds. My ultimate prayer is that many Lives will be transformed for the betterment of Humanity through these messages THE MOST HIGH blesses Me with to share with the masses. Shot out to all my single-mother's. No matter what, trust that You are blessed. You are favored by THE MOST HIGH. Keep Your hand in HIS. Let HIM guide You. HE definitely won't lead You Astray.

To My Upcoming Kings and Queens coming up in single-parented homes, trust and believe that all is well and all will end well! The future is awaiting the radiance of the light THE MOST HIGH is going to permit to flow from within You. Strive that much harder. Knowing that weakness comes from ease. Struggles breed strength. I can relate to Your situation. I've experienced it hands on. All wounds heal over time. Obey GOD. Acknowledge Self. Appreciate Life. Spread Love. Ignite minds. Transform Lives. Inspire others. Walk righteous. Remain faithful in THE MOST HIGH. Never give up. No white flags. Keep Moving. One Love. One Life. One Way. May THE MOST HIGH never turn HIS face from upon You.

CREDITS

Photography: Mr. Harold J. Dobbs

Creative Director of Photo Shoot: Empress Yana J.

Cover Graphics: Mr. Eric "E.Z." Roberson

Editor: Ms. Thelma Morris

Freedom From Bondage

UNHEARD CRIES

Too young to express her pain in words...
More than tired of being neglected...
Confused by the swift motions & constant traffic...
Annoyed by the smell of the fumes...
In fear of all the unknown faces, each day as they enter the room...
Exposed to the exchange of currency for narcotics... far too often & soon...
How would she respond to... if she could... about her food & diaper money being consumed?...
By the habit her mother's slowly being conquered by... would she feel that her life was doomed?

Inspiration: The beautiful thought of someone leaving crack cocaine alone after reading or hearing this.

Freedom From Bondage

EMERGE ("IT'S TIME!")

Broken glass... shattered dreams... rodents & fiends...
True hood exposure... Vultures... G.A. days & roaches...
Spit-fire personas'... While striving to rise... lost souls face the contra...
& bang out to the death... which leads to toes being tagged on shelves...
over blocks to pump poisons... 'til nobody sober's left...
Precious seeds are neglected... Ms. Lady... ain't
seen her seeds daddy since she told him
she was pregnant...
Our family structures are being dissected...

It's time... To Emerge.

Tainted by the worldly substances... so most look at her in disgust... for spreading
herself... far to thin... for the materialistic stuff...
Caking her face up with make-up... feeling the need to be made-over...
Rather than embracing her lovely naturalness... for beauty... she explores...
Wake up boo... Recognize the design that THE
MOST HIGH had in mind for you...
&... be guided by HIS Presence inside...
that HE provided to remind you.

It's time... To Emerge.

*This piece was inspired by occurrences that aren't so beautiful that take place
within the African-American communities.*

Freedom From Bondage

SPIRITUAL MINEFIELD

I done had it up to here with the usual...
'Cause I... pattern my steps according to what THE
MOST HIGH... views as suitable...
My definition of reality... is... life minus distortion...
Fruitless & misguided thoughts, oftenly lead Us to misfortunes...
Justice prevails on higher scales... disobedient souls get their portions...
While...
noble minds indeed recede... to separate from all the madness...
moralizing for refinement's just... one of my chosen battle tactics...
&... premonitions form my mind's shield... in this spiritual minefield...
those who exercise w/ untrained eyes...
get their minds filled...
then publicize the unreal...
See...
the soulless synchronize schemes to stunt the advancement of the masses...
which explains a crack heads aspiration... of securing that last blast...
Discussions of a Higher Power have been taboo'd in school classes...
Could that be linked to some of the teen-age casualties that come across the new flashes?
Through the tunnel of my eardrums... I hear my forefather's freedom songs...
They've awoken me to my calling... to serve amongst the chosen ones...
& have... marked the rebirth... of he who... had fallen out of grace...
Who... now... recognizes "The Garden of Eden"...
as other than just some foreign place...
In Our minds... every thought's a seed... an off-spring...
I share thoughts of Liberation... for the harvest they gone bring...
At one point in time... I was consider as being less than a Man... 3/5's....
But what forces... actually energize those... who
wrestle against My MAKER's plans...
in this Spiritual Minefield?

Inspired by: Dr. Martin Luther King, Jr's, "Letter from Birmingham
City Jail" which was wrote pertaining to Him being arrested
there for speaking out against social injustices & unrest.

PERSECUTION

Simply because of the design... My MAKER (GOD)
had in mind... when HE made me...
I've been... frowned upon...
4 a mighty long time...
but HE's raised me...
up out of the trenches...
from a state of agony... that appeared as being "endless"...
When currency's runnin' short...
is when We discover who our true friends is...
or...
either... find ourselves "friend-less"...
Swollen knots... attract flocks... of pretenders...
Ya'll know...
the kind that act like... they've been down since day one...
from the beginning...
How offensive...
it be... watching 'em expose rows of teeth...
while...
viewing beneath the surface...
all that lies beneath.
Hand-outs are proudly accepted... when you're the one who's breaking bread...
to have the same hands retract themselves...
when you're in need...
Fraudulency...
Life-sized vipers... anticipate strikes!
Ex-felon's are being released... w/ ten bucks & a bus ride...
Is this life?....
Or does that come next?...
It's hard to tell the difference between propaganda & terror threats...
In this land....
in which there ain't no telling what's coming next...
Plenty of...
teen-ager's roamin' around... wondering why they ain't dead yet!
Or lost the best parts of their heads yet!

Freedom From Bondage

*Chemical Warfare's full-blown in the slums where we stay . . .
From the classroom pile-ups . . .
Our youth are slippin' further away . . .
LORD . . . We believe & trust in YOU . . .
To keep & save Us from destitution . . .
No matter how confusing . . .
things may be . . .
in the face of Persecution.*

INCARCERATION

Steel bars smother my visual...
while...
sitting on this steel bunk, reflecting over trials I done been through...
My uncertainty of the outcome got me scratching on my temple...
Parole hold got me dialoguing through speakers in the windows...
To be aware, is to be alive...
Observation's fundamental.
Damn...
mailroom's playing games again... &... these
days are moving slower than Forest...
It's beyond taste & about survival...
So I...
smashes my state portions...
&... enter into bullpens... full of Black & Latino Men...
anticipating good news from their lawyers...
but...
continuances ain't nothing new...
so sick... don't know what to do...
our soul's be scortchin'...
Which gives birth to bottled up frustrations... somebody's always getting hurt...
See... Tension... usually leads to stabbings...
followed up by ten-ten alerts...
fresh cases being passed out... & housing units being dispersed...
Imagine being judged by an individual who's oblivious to your struggle...
Or perhaps...
being represented by a state pretender... who's in cahoose... & it ain't no puzzle...
While enduring inhumane circumstances...
with lost souls... who just made poor choices...
Take a second to visualize despair in the eyes of those in trial rolling the dice... or...
attempt to embody the mindset of an individual freshly sentenced to natural life...
While...
Our fore-parents suffered atrocities that have gone unpunished until this date...
Is justice...
never allowing a fallible Man the chance to rehabilitate?

Freedom From Bondage

Well... If he's not capable of changing then please tell me this...
how could some have possibly changed after acts so treacherous?...
or... state's still exists... who fly the flags of confederates?...
While, for fighting to remain unified some have been labeled as domestic terrorists...
Such a mighty thin line... but the commonalities sit faced up...
According to the population serving time...
only selected groups get cased up... while
My Brotha's carry sharpened iron...
& exit their cells... w/ their shoe's laced up...
I smell a rat... & it's definitely still alive...
hypocrisy's it's name...
&... using lives to obtain wealth...
through the Prison Industrial Complex...
is one of it's major games...
Manufacturing arms... then filling up the jails...
once they serve the purpose of their design...
Create a crisis... then supply a solution... was the
thought on that hypocrite's mind...
Flood the hood with narcotics... take away the jobs & increase the rate of inflation...
For trying to support Our families... or make ends meet...
We can't seem to evade your...
INCARCERATION.

Dedicated to: My People of Color, who "over-populate" the prison industrial complex, B.K.A. "jail houses", within the United States of America. It's a proven fact that there are more Black Men incarcerated today then there was enslaved in 1850.

FREEDOM FROM BONDAGE

Done away w/ my former self...
Renewed in mind...
Blessed to be alive...
Freedom from bondage...
More than a conqueror...
Struggle increases my strength inside...
A whole new language flows from my mouth...
Blessings shower down...
as praises go out...
On trial by fire...
Got my focus on the prize...
Like gold in a furnace...
My soul's being refined...
Heart of servant...
Wearing "selfless" apparel...
Enduring temptation w/ my aim on the sparrow...
Speaking truth to cut through hearts...
while dodging the adversary's arrows...
that fly out to strike us...
like the vibrations of life...
accompanying...
the positive thoughts...
which ignite us...
I often find solitude bliss...
Dig this...
golden...
is...
silence...
This world is full of distractions...
Gotta remain conscious of what drives us.

Inspiration: "And be not conformed to this world: but be ye transformed by the renewal of your mind, that ye may prove what is that good, and acceptable, and perfect, will of GOD." Romans 12:2

SINGLE SISTA

SINGLE SISTA',
My Heart goes out to you for placing your all into making it happen...
Smiling...
while in the midst of tribulations...
Throughout adversities...
still laughing...
As well as, for pulling a load that causes you to feel, as if, the Universe is upon your shoulders...
Yet... keeping your vision centered on GOD...
knowing HIS SPIRIT... "The Comforter"... that molds Us...
SINGLE SISTA',
I understand... you never imagined... doing it all alone...
while carrying GOD's blessing... within your womb...
A seed of promise...
So, whenever gloom... attempts to consume your conscience...
Reflect on the fact that HIS message to you... is that You are favored... &
Never stress on what is happening now...
Trust... that things will grow greater later...
The righteous are never forsaken...
Despite the illusions the enemy paints...
You're a reflection of THE MOST HIGH's LOVE...
A unique expression of HIS grace...
SINGLE SISTA',
Be proud of the skin that you're in...
I adore the way you smile...
even when it's hard to grin...
Tests are gonna come...
Just keep you head up & demand...
Victory...
The belly of the beast will free your Man...
SINGLE SISTA',
1st chosen to be Queen over the land...

SINGLE SISTA', I'm marveled by your in-tu-i-tion ... Not to mention ... your elegant touch & how it shines forth ... I pray for GOD to take away the things that you abhor ... & for all that has been taken away ... I pray that HE restores ... Everything that's in-stru-mental in you spreading your wings to soar ... SINGLE SISTA'.

*Hopefully, these words will embrace & inspire every mother who's a single parent. I know it's difficult wearing a million & one different hats all at once. Trust that GOD will continue to strengthen, provide & guide you, until HE sends you the one who HE created especially for You, as long as, You believe.

DA' WELL WITHIN

I know of a sacred place, that's over-flowing with riches...
Although, it's hidden from natural vision...
It serves as a guide...
for fruitfulness of living...
A place where inflictions gravitate to...
when in search of healing...
& resources for demolition & construction...
are provided for...
when it's for building up...
after destroying...
as in...
subtraction before addition...
It's capable of multiplying...
and dividing...
It breeds the greatest of math-e-maticians...
& even has a voice...
the sad part...
is few listen...
As, it "unceasingly" cries out...
attempting to gain our attention...
while the continuation of our ignorance...
post-pones it's mission...
This place...
is where the connection of THE CREATOR & HIS creations take place...
So those who are in-tune with it...
experience HIS Divine grace...
Peace... truth... life... love... freedom... equality... & retreat...
Growth... joy... justice... & boundless creativities...
When lacking strength... I draw from it...
& experience rejuvenation...
& the immediate... absent-mindedness...
of all my frustrations...
It... better prepares Us...
to serve the purposes...

Freedom From Bondage

We each must carry out...
& provides shelter from the rain...
as storms form within the clouds...
This location I speak on... is where patience, has formed it's house...
The energy contained within it...
has given me the power to speak out...
& the ability to awaken the dead...
so they may flow with life again...
like the Messiah taught Us how...

...Which was mistaken for sin...
& lead to Him forgivingly pleading,
"FATHER, Forgive them."

Never lacking in inspiration...
this place is meditational to the soul...
Shaping me... as if I were made of clay...
for It's duty is to mold...
me...
further into the image of... HE... who chose me...
to become a light within this world...
in the ways that HE shows me...
How...
Without HIS instruction...
I have nothing...
Which proves that HE knows me...
& has placed this well within me...
So, I'll get to know Him more... growingly!

Speaking on THE MOST HIGH's KINGDOM within Man/Woman.

LIBERATION

I'd rather' be dismembered... or murked... than to live my life out... as a slave...
Groomed by tribulations... sharpened by pain
survival's flowing throughout my veins...
I... close my eyes... & vision new horizons... & progress being made...
Although, the past is distant...
I'm often reminiscing...
& missing the ol' ways...
In these days in time...
the enemy raids the mind...
aiming to snatch away whatever's
fruitful...
So I...
counter-act... dude's attacks...
by making Myself useful...
See...
I grew up in the system... &... in it's eyes...
We're equivalent to live-stock...
In-between packed prisons...
&... all the lives that expire everyday... on the block...
from
"fully" auto-matic 9 shots"...
Accompanied by those strung-out on crack rocks...
Equal...
turbulent times...
Slip-n-fall...
Surface-n-shine...
Dreams of a massive resurrection... breathe within my mind...
It's past time...
Signs & Wonders... encompass Us...
Nothing but thoroughbreds run w/ Us...
Our Chosen Generation... has been set up for failure... Nevertheless...
It's time to rise up...
O' Sacred Nation...

Is . . .
What I've been birthed to tell Ya!
Liberation.

"A Call 2 Greatness!"

Freedom From Bondage

ECHOES OF THE FEMALE MOSES

Got no time to be stressin'...
It's a must...
"WE" keep pressin'...
&...
sharing jewels w/ the youthful generation...
accumulated through life's lesson's...
Struggle inspires me...
&...
has bred...
the determination of a runaway slave who fled...
Reachin' back as I rise...
My blood-shed...
sweat & tears...
have given birth to pride...
Another soul expires...
as a barriage of gunshots flood the night...
To stay afloat...
We must fight...
persevere...
&...
shed light...
speakin' truth to ignite...
each other's soul's
&
take flight.

Inspired by Ms. Harriet Tubman A.K.A. "The Female Moses"

TAKE IT IN STRIDE

Unemployment's on the rise... at the same time as gas prices...
The broken home syndrome... within the hood... surpassed a crisis...
Roadblocks applying for jobs... make it a task to last righteous...
So, We prostrate & begin to pray... in desperate search of GOD's guidance...

Flashlights blind Us... through the window of Our pulled over whips...
when the man's behind Us...
Behind Us, with the ill intentions that dirty's how they'll find Us...
I loose the "Keys of The Kingdom"
on demonic forces trying to bind Us...
Through faith We our healed...
The Messiah said that...
not Simon...
Take it in stride... Take it in Stride... Take it in stride... Let's strive & thrive!
Allowing the schools shutting down...
to be the motivation within Our eyes...
Spirits & minds...
Observing the fact...
that the beast is kidnapping Our younger generation...
while Our "Holier than thou" complexes...
futher increase Our seperation...
85% of juveniles locked away...
wandered aimlessly out of broken homes...
I could never discredit my Sista's though...
Ya'll been working it to the bone...
Nor point the finger at my Brothas'...
The bottom-line...
is...
We need a change...
A Break-through...
or plan of action...
to transform the fashion...
of which are lives have been arranged...
Renewed in mind...

I take it in stride!
The Spirit of Resurrection's indeed real...
I know...
I was walking in my grave...
All Glory to GOD...
today that I live...
My adversaries rise against me one way...
prior to fleeing before me in seven...
Like young Dre 3000...
Seven...
The number before the number...
of the first letter of
Heaven...
Convicted felon... unafraid of conversion...
preferring to speak life into existence these days...
rather than time-serving...
In the midst of Our dreams & visions...
opposition... fall within our eyes...
However, despite all the distractions...
We must strive
&
TAKE IT IN STRIDE!

Aiming to encourage the will to survive throughout these difficult & trying times.

Freedom From Bondage

SOUL SURVIVOR

Words are inadequate to describe my appreciation for all that You have shown me...
'Though, at times I've been hard-headed...
even now those lessons mold me...
Standing strong through it all...
You never caught a case of cold feet...
As I ran the streets...
disoriented...
allowing ignorance to control me...
Placed myself in a position...
in which I wanted to murder the old me...
Recreated in mind...
reflecting over times...
I visualized You falling asleep...
after work...
Determined to provide...
Right back out before the sunrise...
w/ no traces of weariness in Ur eyes...
Shining example for upcoming Queens...
Taught me everything isn't all that it seems...
How blessed that I am...
As well as, the importance of focusing on my dreams...
alleviating the nonsense & keeping my nose clean...
Made the most out of the least...
Silenced storms through your faith...
Always seemed to make it lighter...
Inspired me... to believe... that I can journey much higher...
Thank GOD for blessing the Universe...
w/ such a Soul Survivor.

Inspired by: My Mother

SHELTER US LORD

My taste buds been craving a new flava!...
Had to slew off the past to bring forth new beginnings...
Embodying the unique mindset... of a Warrior... on a mission...
Thinkin' back... over previous years... in agreement
with Marvin... I just wasn't livin'!
See the flesh is condemned to death & is weak...
where the SPIRIT is indeed willing...
Redeemed by the precious Blood of the Lamb...
So, it's Key to remain diligent...
I'm... strivin' to embrace the faith of Abraham...
Transformation's igniting my adrenaline...
Dry tears I shed...
as I envision the youth in battle...
realizin' that there are jails cells...
ready to swallow 'em captive...
&
to place their lives in shambles...
Ain't nothin' nice being at the bottom of a "bottom-less" pit...
with...
your back against the wall & pockets fulla lent...
just...
A dollar & a vision...
I Lost a decade to youthful ignorance...
Yet by...
faith & lessons learned...
I'm gone rise up through persistence...
For...
Whenever in need of guidance...
Lord...
I... seek Your face...
I'm more than grateful... of being a partaker... of Your grace...
Teach me Your ways...
Be my lamp...
Uplift my soul...

Freedom From Bondage

Be my ramp...
True wealth resides within...
FATHER, YOU within me...
is far greater than him...
I'm distant from perfect...
Yet, have a calling...
that must be fulfilled...
know I can't keep stalling...
while gazing into the eye's of reality...
I'm tired of getting up...
after constantly falling...
I've abolished all fears...
with the exception of YOU (GOD)...
Graveyards from gunshots claim my peers...
Yet & still...
a ray of hope keeps me grounded...
on the battle ground...
where The Fam Prayers & YOUR (GOD) Angel's surround me...
Well aware of the fact that...
my thoughts are life...
Can't be blowing moments...
rolling dice with life...
In this era of... wars, rumors of wars & plagues...
enduring these last days...
fulfillment of prophesies manifesting themselves...
entire nation's filled with rage...
Gotta monitor what we consume...
A vessel of death these days be the food...
B-12's... giving birth to steroid chicken...
as... recalls on beef... flood the news...
Babies having babies... Youth wackin' youth...
As a form of ventilation... some aim & shoot...

*Accustomed to the darkness... We "about-face" truth...
& devour 80 Proof...
to massage Our blues...
Yet...
the sufferings of the present...
could never measure up...
to what's in store...
& worth fighting for!
SHELTER US LORD.*

Freedom From Bondage

THE FUTURE

I'm amazed @ what I see...
when I imagine where your paths will lead...
It always brings a smile to my face, viewing the promise of your destinies...
So youthful...
Yet, filled with the potential...
to be whatever you each dream to be...
Have faith in GOD above everything else...
& ask HIM...
to increase your capabilities...
Whether you know it or not, you each are major sources of my inspiration...
Always eager to learn something new...
Know...
that you are GOD's Most Precious Creation's...
The future depends on you & the light that shines within you...
The world needs to be healed of it's wounds, from the Love that flows out of you...
Positive words carry the power w/ them... to ignite other minds...
Be mindful...
that your actions & deeds...
will have an effect on other lives...
Nothing's impossible...
continue to shine...
Like stars in the mid-night sky...
As you bless the world with your personalities...
I thank GOD for your lives...

THE FUTURE DEPENDS ON YOU!

Inspired by: The Talented Youth. Especially, those growing up striving against all kinds of odds who have been labeled "disadvantaged."

CHOSEN SEEDS

Echoes of gunblasts flood the night...
Another untimely departure...
A lost of life...

Another mother grieves after watching her son die...
In cold blood...
We can rise above...
with Black-on-Black Love...

My blood... My sweat... My tears... My life...
My struggles... are constant... I'm inclined to fight...
Those walking in the darkness... are blind to light...
Gotta grind all day... if You wanna shine all night...

This pain is endless...
It can't be placed in words...
no pretending...
Embody the unique mindset of a warrior on a mission...
& discover me...

Schools being cut out of the budget puzzle me...
Let's walk across water ya'll...
with everything that struggle breeds.

We are...
The Chosen Seeds!

Inspiration: Parent's burying their Sons' & Daughters'.

Freedom From Bondage

NO WHITE FLAGS

I'm condemned for my views...
as was the Messiah...
Yet, I'm growing accustomed... to embodying actions... sure to take it higher...

Time spent in confinement's... given birth to a climber...
As We climb up... let's aim to inspire... fellow striver's...

So... We may rise up...
&...
serve the purposes of Our designs...

Created "god-like"...
We must fight...
to set free...
shackled minds...

Rather than doubting that We gone overcome...
Victory IS Ours...

Got to remain resistant...
to tossing flags in...
through these trying hours.

NO WHITE FLAGS!

FOREIGN FABRIC

I'll give my last... to those in need...
w/ no greed in me... nor expectancies...
How We carry today... plants tomorrows seeds...
The absence of truth... is... equivalent to weeds...
in need of being uprooted...
avoid the footsteps of the foolish...
at all cost...
It's one thing to say it...
A whole 'nother to do it...
To the adversary I'm a nuisance...
For eradicating my old ways & embracing my newness...
I'm allergic to haters... fish... raids... & those who spread rumors...
Got potential & visualize myself... becoming more than just a consumer...

THE CLOTH I'VE BEEN CUT FROM... CLOTH
I'VE BEEN CUT FROM... THIS
HERE'S... THE FABRIC... OF THE
CLOTH THAT I'M CUT FROM...

I'm... exotic in my nature... my vision is centered... on what's greater...
We gotta go get it now... since We ain't been promised later...
I speak life... for the purpose of enhancement...
So many lives damaged...
& many find it hard to manage...
Been in the trenches... since... I was young...
Too many in shambles... where I'm from...
I pray for 'em...
as well as...
for those around me...
Gotta swim through the currents... can't let the pressures drown me...

THE CLOTH I'VE BEEN CUT FROM... CLOTH
I'VE BEEN CUT FROM... THIS
HERE'S... THE FABRIC... OF THE
CLOTH THAT I'M CUT FROM...

Breathin' freely... It just ain't in me... to be the one to complain...
no stranger to pain... learned to maintain...
by musclin' through it... simply & plain...
At point-blank range...
my life could've ended...
if that "unit" didn't jam...
I could've been finished...
Preserved through the worst...
So, I'm expectant of the best...
that has yet to come around...
My faith is my vest...
Endurance is increasing as I go through each test...
Blessed beyond words... got no room for stress...
Men sharpen men...
Iron sharpens itself...
Pop's taught me how to hustle & play the cards I've been dealt...
Mom's showed me love & how to fend for myself...
While supporting 7 mouths...
My dog & herself...

THE CLOTH I'VE BEEN CUT FROM... CLOTH
I'VE BEEN CUT FROM... THIS
HERE'S... THE FABRIC... OF THE
CLOTH THAT I'M CUT FROM...

Freedom From Bondage

I'm... waging war...
Against the same failures...
I've been set up for...
For instance...
the way prison gates become revolving doors...
or...
being the underdog...
knowing I'm counted on to score...
Drama...
stay coming my way...
'cause the adversary's counting on Me to soar...
he see's me growing out of this world...
absorbing the ways of The Lord.

THE CLOTH I'VE BEEN CUT FROM... CLOTH I'VE BEEN CUT FROM... THIS HERE'S... THE FABRIC... OF THE CLOTH THAT I'M CUT FROM...

SERVANT'S HEART

I'm appreciative for each breath Lord…
Your mercy & grace covers me…
when life's obstacles aim to smother me…
or when the adversary's tryna puzzle me.

I'm inspired by YOUR ways…
Progressing & thinking more in ways that YOU do…
Giving back to the youth…
They shutting down schools…
Eviction notices been raining the blues…

Yet… my faith lives in YOU…
Even as I'm walking amongst the dead…
I trust the odds are in my favor…
LORD, You keep me fed…
You extended Your arms & bleed.
Placing all of Our lives ahead of Your Own…
Humility shown…
placed You on the Throne…

Constantly… my mind zones…
I appreciate YOUR ground beneath my feet for keeping me strong…
Got my Full Armor on…
I'm engaged by storms.

Yet… fearless…
Viewing the world through YOUR (GOD) eye's…
is…
when I view life the clearest…

Around here, everybody trying to prove they're the realest.

But who's actually willing to sacrifice?
Not in terms of finances...
I'm speaking on lives...
We've prefered the dirt for too long...
It's time to reach for the sky.

Inspiration: The Messiah, Jesus Christ

Freedom From Bondage

KINGDOM FORMIN'

My people are immune to collisions with the law . . .
We teach the found . . .
after reaching the lost . . .
& ride out on enormous rims . . .
unaffected by the cost . . .

As versatile as, water & sun-kissed . . .
w/ royal blood . . . in that order . . .
I find peace . . .
tapping into my mind's eye . . .
painting mental portraits . . .

1st born seed . . .
determined to rise . . .
Trails of pain are captured in these eyes . . .

Strengthened through struggle . . .
Muscle . . .
Combined . . .
w/ lesson's life has taught me . . .
equal my grind . . .

Solitude has shown me . . . to see with my mind . . .
The Sword of Spirit digested . . .
help me see through these times . . .
We're enduring . . .
I'm tired of seeing the youth neglected . . .
As well as, my people mourning . . .
Where life is being celebrated . . .
GOD's KINGDOM is forming . . .

Prosperity Over Poverty . . .
as I speak . . .
the truth is touring . . .

Across the globe . . .
& into every ear willing to hear . . .
the echoes of a servant's soul . . .

who's vision's clear . . .
Word's heal . . .
as miracles are being performed . . .
Each one teach one . . .
must become the norm . . .

It takes a village to raise a child . . .
too many adolescents running around wild . . .
who are reachable . . .

Just . . .
anticipating the day that someone tells 'em . . .
it's okay to smile . . .

New life is feasible . . .
Our goals are feasible . . .
when sought after . . .

One milligram of faith . . .
make obstacles scatter . . .

Let's be Doer's of The Word & rise above the chitter-chatter . . .

Whatever . . . We toss out there into the Universe revolves . . .
There . . . truly ain't no telling . . . what Our effortz may solve.

Freedom From Bondage

PARADISE STILL LIVIN'

*From making collect calls...
to dialoguing on Androids...*

*Enduring Our Most Darkest Moments...
to experiencing light...*

*Refined by fire thru the trials...
From frowns to smiles...
'cause restorations in sight...*

*From poverty to prosperity...
Despair to hope in great clarity...*

*Lent-filled pockets to wealth in abundance...
Patched-up jeans...
to self-schedule running...*

*From homelessness to sitting lavish...
Being disregarded to living classic...*

*Look @ 'em...
they're dependant upon Us now...
who use to stay laughing...*

*First-to-last...
Last-to-first...
Born to breed... & have dominion on earth...*

*I've been...
resurrected from the graveyard while still walking...*

*Now I'm...
reviving the lives of deadened souls through talking...*

Freedom From Bondage

Speaking life into existence...
In refusal to be diminished...

I've...
Evaded the pits of hell...
By keeping' THE MOST HIGH in remembrance...
Just as a river never forgets it's source...
tolting the torches...
overcoming all obstacles reborn...
Strengthened as neva' before...
Making progress...
eager to explore...
Exposing raw talent while entering doors...
that...
no man can shut...
As...
doors open...
that...
no man can close...
Experiencing an intoxication that voyages beyond smoking...
That only increases...
& increases...
1,000 times more...
Blessed...
To Bless others... as We increase more...
Witnessing the same thangs come to fruition...
in which We've been aiming for...
In the midst of wars & rumors of wars...
Favored...
Gifted thought patterns...
far sharper than razors...
or Ginsu's...

Accompanied by radiant characteristics...
Still eat fried chicken & kick it...
so don't get it twisted up for a minute...
Homey...
We don't condone it...
Uplifted...
No Worries...
PARADISE STILL LIVIN'

Inspiration: The thought of Heaven reigning within hoods "World-wide" that poverty, drugs & violence have had a strong presence within after sitting amongst the homeless while writing this.

BLESSINGS

Blessings fall Our way . . .
so . . . We can be blessings unto others . . .
My life is my service . . .
unto those the struggles smother . . .

A part of it . . . so I mimick nature . . .
w/ no holding back . . .
I have no time to slack . . .
The surest way to reap a descent harvest . . .
is . . . giving back . . .

Self-denial leads to fulfillment . . .
Once the foundation has been established . . .
the times comes for building . . .

Resources are made available . . .
instrumental to displaying Our gifts . . .
We just got to recognize 'em . . .
&
be willing to put in shifts!

It's reachable . . . once it's viewed . . .
Can't grow accustomed to depressing news . . .
While striving for wholeness . . .
Gotta exercise boldness . . .
Can't be afraid . . .
to venture what's new . . .

Freedom From Bondage

*As this world changes . . .
Many working wonders . . .
&
still just maintaining!*

*It's there's for the acceptance . . .
That's no braining . . . If We don't except it . . .
We just left danglin'.*

PARADISE

Flirting w/ the thought of experiencing your grace...
never fails to put a smile on my face...

Accompanied by...
a taste of the joy you place in the hearts of those who meet you...

Has a brotha' of my caliber...
determined to reach you!

Once I do discover you...
will you embrace me with open arms...
& award me w/ your precious treasures...
trusting they'll be free of harm?...

Although, some have taken you for granted, you can confide in me!...
I recognize your light is of extravagance...
& will forever adore your beauty...
Whole-heartedly, I'll admire the rejuvenating ways you possess...

I... long for the hour I experience my best...
I've already projected how nice that would be...

So, I'm willing to sacrifice...
in order to wed you...
PARADISE!

SET ME APART

Getting to know you . . . is gonna require my patience . . .
It's evident . . . that hurtful situations . . .
have caused you to place restrictions . . .
on the way you carry relations . . .

Reflections . . .
of your cautiousness relayed the message . . .
through your eye's . . .
Your intuition . . .
sees me as being authentic . . .
Yet . . .
you're confused as to how to feel inside . . .

Fluctuating . . .
from arousal . . . sparked by our conversations . . .
to . . . your heart's fear of disengagement . . .
After . . . the build up of uncontrollable emotions . . .
grow beyond their initial stages . . .

I know . . . that you're . . .
fed up with all the lies . . .
& those . . .
woman on-the-side surprises . . .
& trust . . .
that if you weren't worried about all that . . .
you'd be more inclined . . .
to try it . . .

True enough . . .
we can't believe everything spoken . . .
That's surely a trait of the foolish . . .
However . . .
my actions measure up to my words . . .
I see the potential in us & don't wanna lose this . . .

Freedom From Bondage

Beautiful bond that's beginning to form . . .
no doubt about it . . .
it's far from the norm . . .

I wanna be a vessel of light . . .
who . . . brightens your life . . .
by proving it alright to move on . . .
The last thing on earth . . .
I want you to feel . . .
is me . . . applying any kind of pressure . . .

Acknowledging my role as a Natural Protector . . .
I envision myself . . .
loving you better . . .

than those who have made previous attempts . . .
who have fallen short . . .
Of course . . .
there's no sympathizing for them . . .

They've given birth to the infinite possibilities . . .
that lie before You & I . . .
& in my eye's . . .
You are a gem!

A prize worthy of striving for . . .
With a personality to be adored . . .

I realize it more & more . . .
the deeper . . . into you that I explore . . .

Therefore...
I don't mind you taking your time...
to assess... the feelings you possess...
However, @ the end of the day....
when all's said & done...

SET ME APART FROM THE REST!

* A sincere Brother willingly accepting the challenge of a skeptical Sista who has been scarred in the past relationships despite the walls he views before him determined to prove his worthiness of her time, energy & heart.

FIGHT W/ LIFE

I often wonder how the hood would be...
if We... carried each other... as Kings & Queens...
When it comes to our mannerisms toward one another...
I dream...
of this w/ my eye's open...
fre-quent-ly...

I mean...
evading the self-hatred...
& jealousy... We've been plagued with...
Ya'll know...
the psychological slave shhhhhhh!...

My Mental Kingdom pauses...
to honor that occasion...
Despite the hardships We've been faced with...
Our genetic make-up contains trailblazing...

Amazing Creations...
flood my sight...
when I lay eyes upon Our Tribes...

We fight w/ life to get ahead...
& for better...
remain prepared...

w/ "spear-like" ideas in mind...
hunting down...
success to wed...

<u>UNFORGOTTEN</u>

You're invisible to the naked eye... but never forgotten!

See...
I'm conscious...
that You've journey into eternity...

Where time no longer exists...
After departing the earthly vessels...
THE MOST HIGH's SPIRIT was contained within...

To reconnect...
w/ THE CENTRAL SOURCE (GOD)...
WHO'S All-Encompassing...

Your efforts were never in vain...
Untimely departures...
taught Us lessons...
to lead Us along the way...

I'm reminded of Your smiles...
while gazing upon the sunrays...

In the midst of Fall breezes....
I witness the leaves clap...
& recognize that...
As Your applause for Our righteous deeds...
&... receive that...

You're invisible to the naked eye but Unforgotten!

Dedicated: To My Family Members & Comrades who've departed out of the physical attire & are present with THE MOST HIGH (GOD).

Freedom From Bondage

MILESTONE

90 years is a Milestone...
The celebration of Your Special day is something that We can All smile on...

The sacrifices that You've made...
have enhanced Our lives...

The demonstration of the importance of Family...
is envisioned within Your eyes...

From within Your soul...
The truth about Our People... is that...
We grow up... & not old...

There are so many meaningful things that "WE" each are thankful for...
WE definitely thank GOD...
for the way Your character glows...

You're a shining example... to the world...
of a Faithful Husband,
Humble Servant,
Brother,
Father,
Grandpa,
Great-Grandpa,
Cousin & Uncle.

WE thank GOD for allowing Us to be blessed by Your Royal Presence.

Dedicated to: Uncle Fred. Writing on the Behalf of Your Family Members & the Numerous Hearts that Treasure Your Style.

MS. NATURALNESS

Ms. Naturalness...
I admire the way your style shines forth w/ elegance...

I'm spoiled each time you smile...
sending off those vibrations of... blessedness...

With a walk of pride in self... &... of joy...
Your personality's... so... Heaven-sent...

Shea butter... causes your skin to glow...
Although... it's deeply concentrated w/ melanin...

Hand's down... you're a masterpiece...
It's... such a blessing... to have you in my presence...

Lesson's learned have enlightened a Brotha... to carry you in that fashion...
It massages my heart... to say somethin' hilarious
& enjoy the sight of you laughin!...

This here... is... beyond visual attraction...
Your words venture into my ears... &... bring about a certain satisfaction...

In the middle of handling business...
I often... vision Us relaxin'...

Your company's soothing...
like incense & aged wine...
while...
listening... to good music...

Our bond... is... far from the norm...
the best of both worlds...
movin' in unison!
Ms. Naturalness... Keep on doing what you doin'!

PROMISED DAYS

Let 'em be confounded & put to shame...
that seek after my soul Lord...
Positive thoughts to conquer the negativity that surrounds Us...
My mental explores Lord...

I'm financially distraught...
could peddle dope...
Just choose not...
When only a dollar... is in pocket...
Your (GOD) gifts from above... place me on top...

No doubt...
YOUR wealth is endless...
While... currency perishes...
from within our grasps...
like marriages...
YOU are The Beginning...
&
The Ending...

Alpha... & ... Omega...
Author... & ... Finisher...
of...
Our Faith...

While time waits for no man...
YOU are timeless... & ... Reign without debate...

When trials attempt to drown me...
YOUR faithful ways never forsake...

Freedom From Bondage

I find refuge in YOUR WORD... &... YOUR HANDS mold me like I'm clay...
Converted from former ways...
It's the new man... that I embrace...
The blood flowing through my veins...
is by... YOUR (GOD) DIVINE GRACE...
By thought w/ YOUR HOLY BREATH...
YOU spoke the Universe in place...

Made In YOUR Image & After YOUR Likeness...
We've been blessed to do similar thangs...

A Royal Priesthood...
Peculiar Creations...
A Holy Nation...
Born to be Kings...

w/ Our Queens standing beside Us...
Like Coretta & Dr. King...

Guide Us in Spirit...
Heal Our Wounds through Our faith...
Convert the poverty Our children face...
FATHER make known... YOUR Promised Days.

Inspiration: GOD's PROMISE to HIS seeds.
Psalm 37:40; "And the Lord shall help them, and deliver them: he shall deliver them from the wicked and save them, because they trust in him."

SIGNS & WONDERS

The rays of the sun share YOUR (GOD) promise of a new beginning...
Signs of new life can be viewed in the greenery...
My eye's adore gazing upon the works of YOUR HANDS...
The sight of children playing kill the hopes of the enemy...

Growth is beared witness to...
where stagnation existed...
Progress is being made by those who almost quitted...
The benefits of being one of YOUR Chosen...
placed a new song in my mouth...
It's amazing...
how YOU respond to...
&... renew...
souls' that cry out...

A peaceful breeze fills the air...
The door is opening...
I'm almost there...

Questions are answered as We look to the sky...
A shovel is refined...
in the furnace when tried...

Struggle breeds strength...
Through strength comes endurance...
Communing w/ GOD in solitude...
leads Us to assurance...

*Miracles are performed by sharing a positive word with others...
Customized to deliver & strengthen 'em...
from oppressive spirits that smother!
Sign's & Wonders.*

*Inspiration: Witnessing the beautiful atmosphere in the Spring,
as the Earth is being resurrected from it's demise.*

HEDGE OF PROTECTION

Lord...
I ask You to place a Hedge of Protection around the Hood World-wide...
May our Elders, My Generation & Youthful Souls experience Life...
And Life more abundantly...
As well as...
YOUR peace, grace, mercy, growth & increase...
Live rather than die...
I'm Tired of seeing loved ones of fallen soldiers...
w/ rivers flowing from their
eye's...

ABOUT THE AUTHOR

Ryan "Liberation" Baldwin was born on May 10, 1979 in Evanston, Illinois. He spent his youthful years there, on Chicago's Northside, and in College Park, GA, before returning to the Northside of Chicago, and getting himself in a situation that transformed his life forever. While living in separation from society, Mr. Baldwin had to swiftly learn discipline and to stand ten-toes down, to fend for self within the jungles of the Illinois Department of Corrections from the tender ages of 17-to-27 years of age.

With plenty of time on his hands, he learned from his mistakes, as well as, from the shining examples demonstrated before him, by family members and loved ones. He embraced GOD & began establishing a relationship with HIM that's still alive. He also discovered his passion for writing poetry with positive messages customized to inspire, uplift & encourage others to embrace GOD and experience the light which THE MOST HIGH had placed before HIS path.

Mr. Baldwin humbly gives GOD all the glory, praise & honor for the good in his life, looks beyond the difficult, expects the best, even through the worst of times & sees the condition of the Black Community in America as being one of his major inspirations for writing.

He has found self-expression as a marvelous way to release stress & unneeded energy. He also attended Lake Land Community College while incarcerated and earned his Associate's Degree, undertook Business Management, Public Speaking, English, Strategies for Life, etc....

Mr. Baldwin, is also a Motivational Speaker/Mentor. He volunteers with Destiny's Changers International, LLC. He has record of Volunteering in youth programs and envisions himself establishing an enrichment program for "at-risk" youth growing up in urban communities within America.

ABOUT THE BOOK

"Freedom from Bondage: The Poetic Messages of a Warrior", is a compilation of 30 Spoken Word works inspired by The Holy Spirit and customized to inspire the lives of others and encourage faith in THE MOST HIGH, as well as, the gifts that HE has blessed each one of us with, for the purpose of empowering HIS Chosen People to unceasingly fight the good fight, as we face various adversities, trials and tribulations. The messages contained within this unique piece of workmanship contain "soul-penetrating" words impactful enough to abduct the attention of their readers, as mental portraits are being painted by them.

"Freedom from Bondage", contains stimulating subject topics ranging from single-motherhood and poverty, to unwavering determination and praise. It is a celebration of where faith will lead us to when we believe that THE MOST HIGH is for us, has pre-established the pathways before us, and that nothing formed against us will ever prosper. Expressions of pain are entailed between these pages, as well as, the promise of a brighter day.

"Freedom From Bondage", is living proof that even after incarceration or surviving through the devastating hardships we encounter in life, nothing can stop GOD from moving through Us, around Us, or on Our behalf. This book serves as a "vessel of light". It aims to ignite minds to hope, to dream, to set goals, to strive, to grow, to create, to accomplish, to overcome, and to recollect that impossible is nothing.

"Freedom From bondage", demonstrates unconditional love, purposefulness, servanthood, strength, determination, victory, steadfastness, humility, intuition, vision and creativity, amongst numerous other matters of great significance. It's not only an invitation into Mr. Baldwin's world, but is also a journey through his struggles. This uniquely worded compilation of poetic messages exposes how freedom from all the unwanted energy, self-defeating behavioral patterns, and/or negative thoughts, can be experienced through self-expression. Since discovering peace & freedom through writing, it has lead Mr. Baldwin to making this book available to others.

www.ingramcontent.com/pod-product-compliance
Lightning Source LLC
Chambersburg PA
CBHW021023180526
45163CB00005B/2084